An Alphabet of Anthropomorphic Animals Coloring Book

by Rebecca Thornburgh

For Brigid

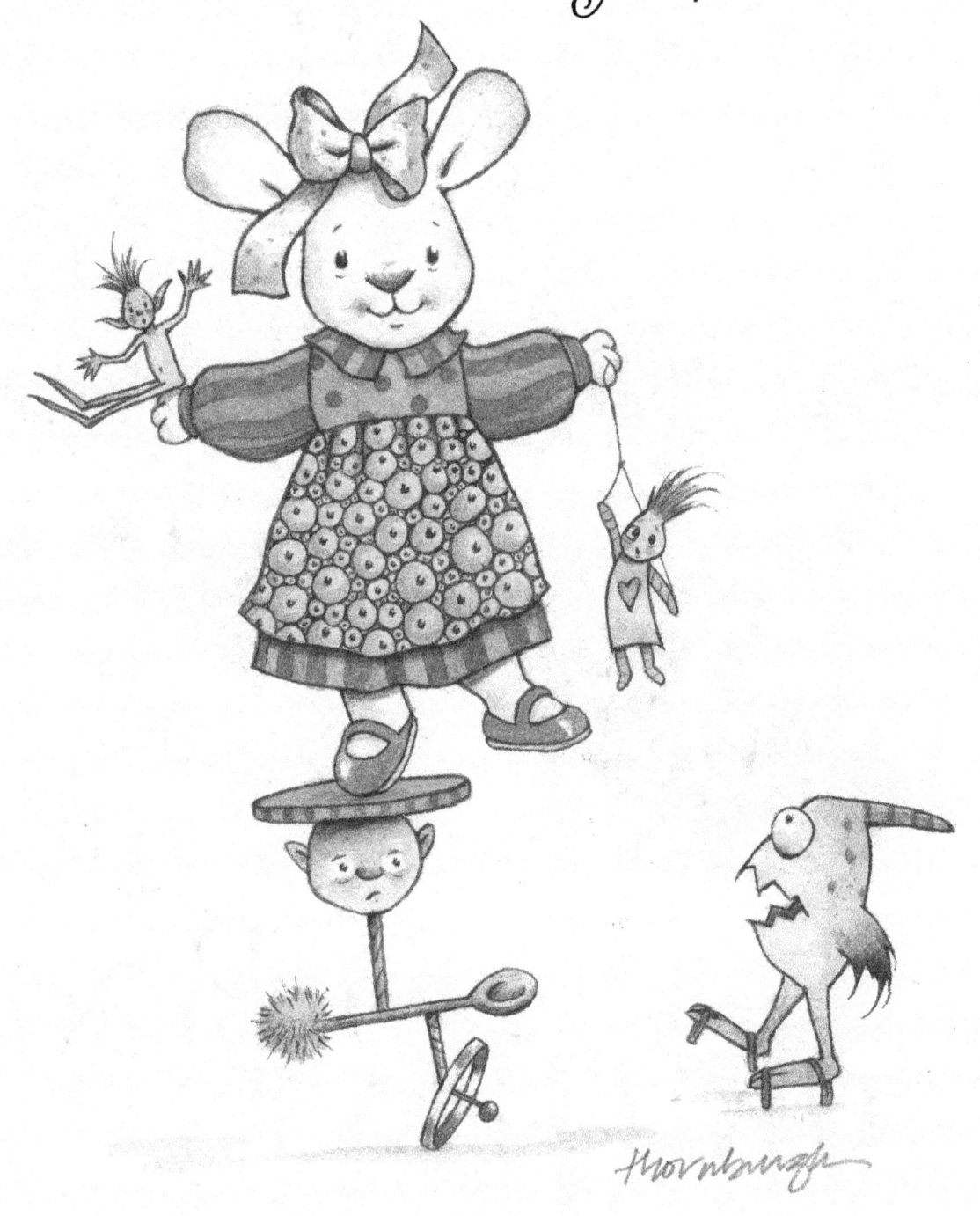

© 2015 Rebecca Thornburgh. All rights reserved.
ISBN 978-1-329-59120-2

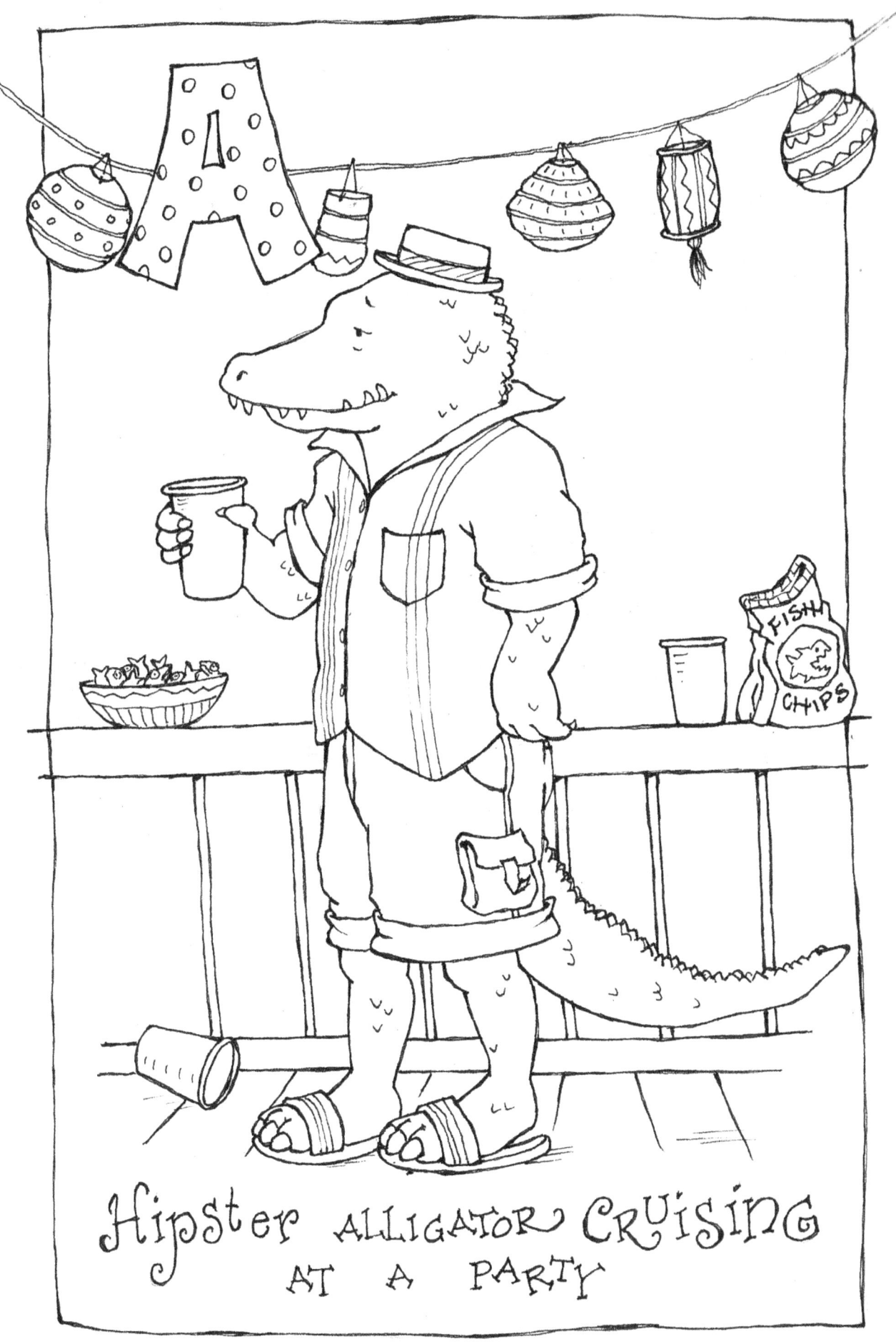

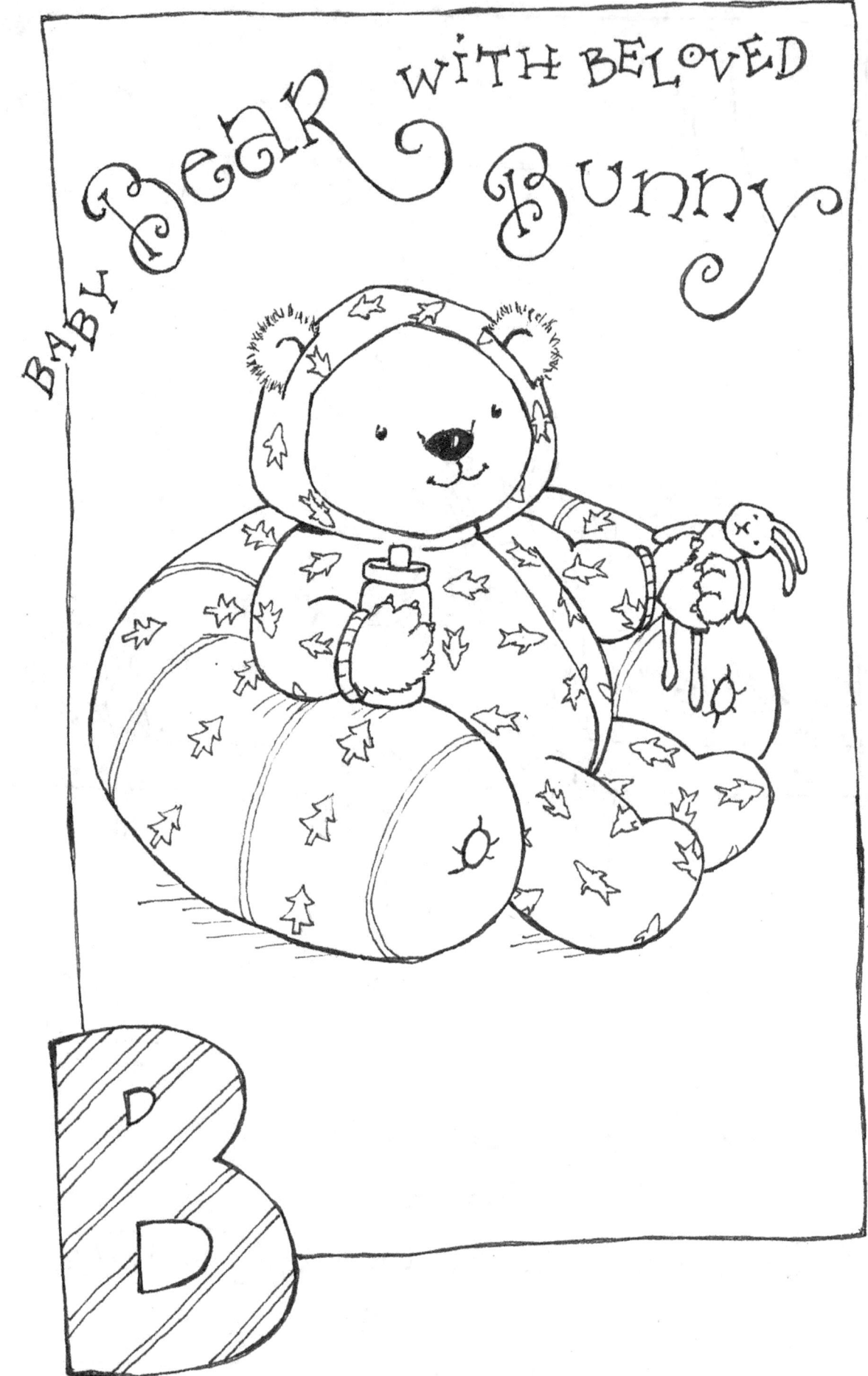

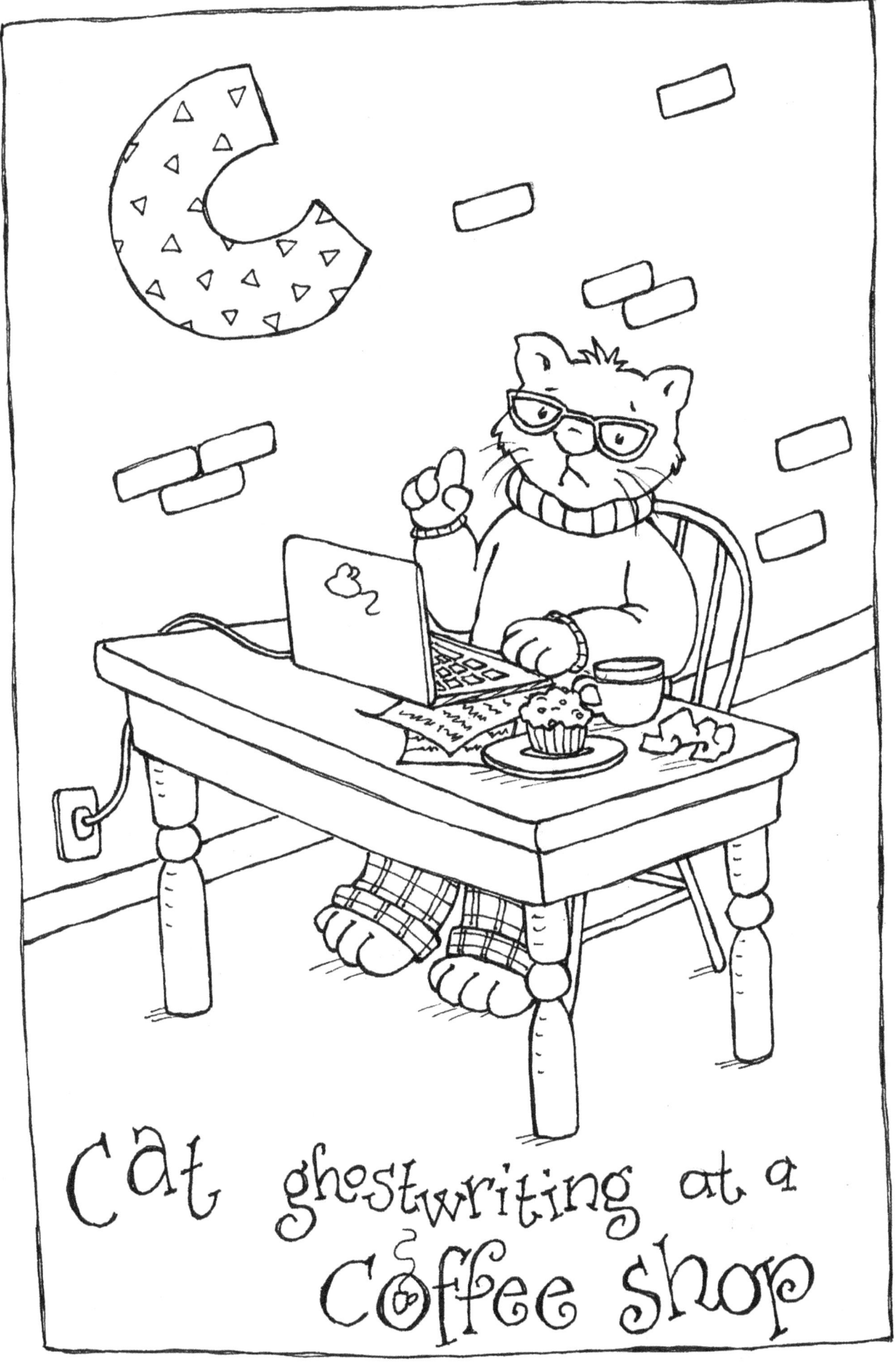

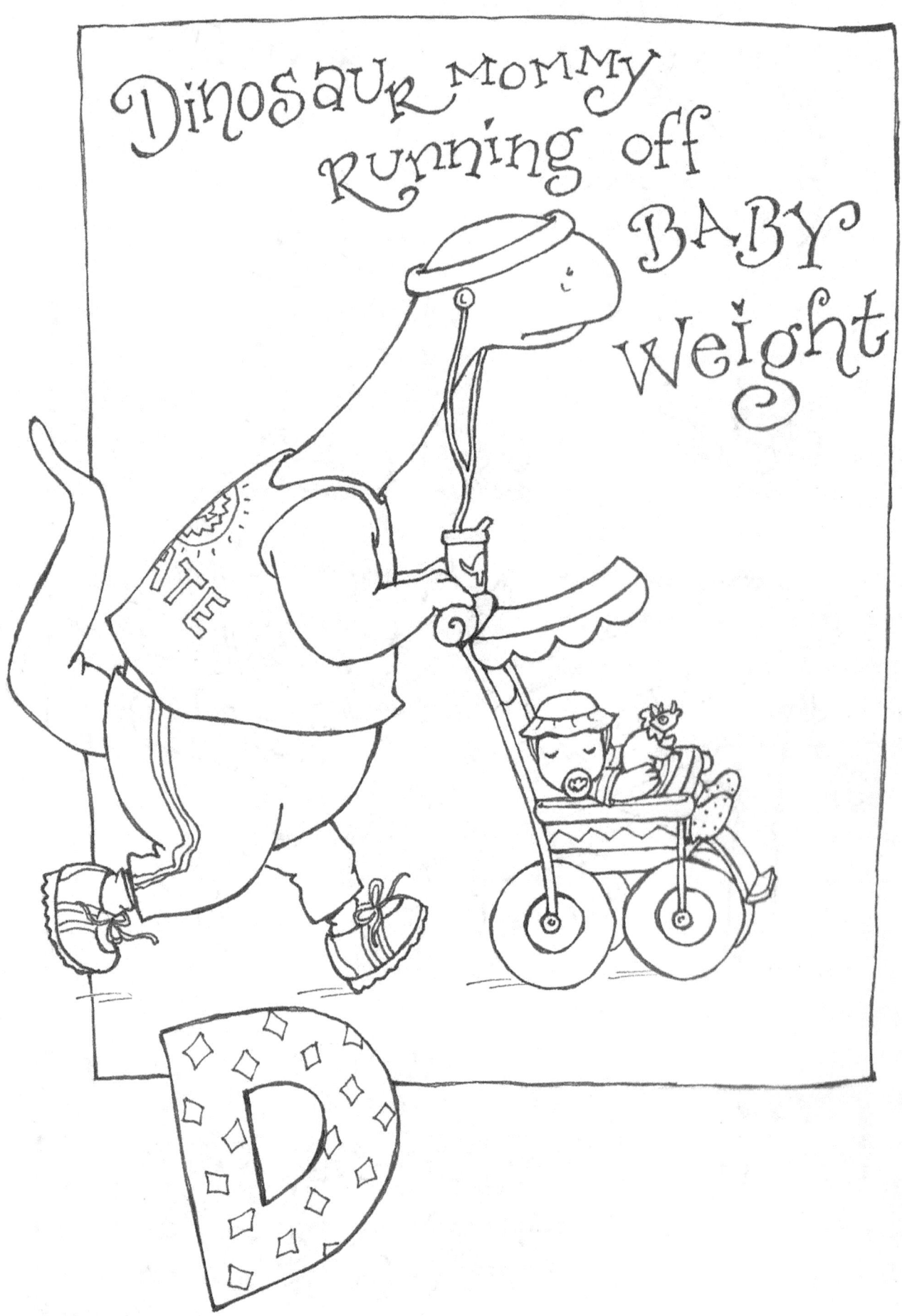

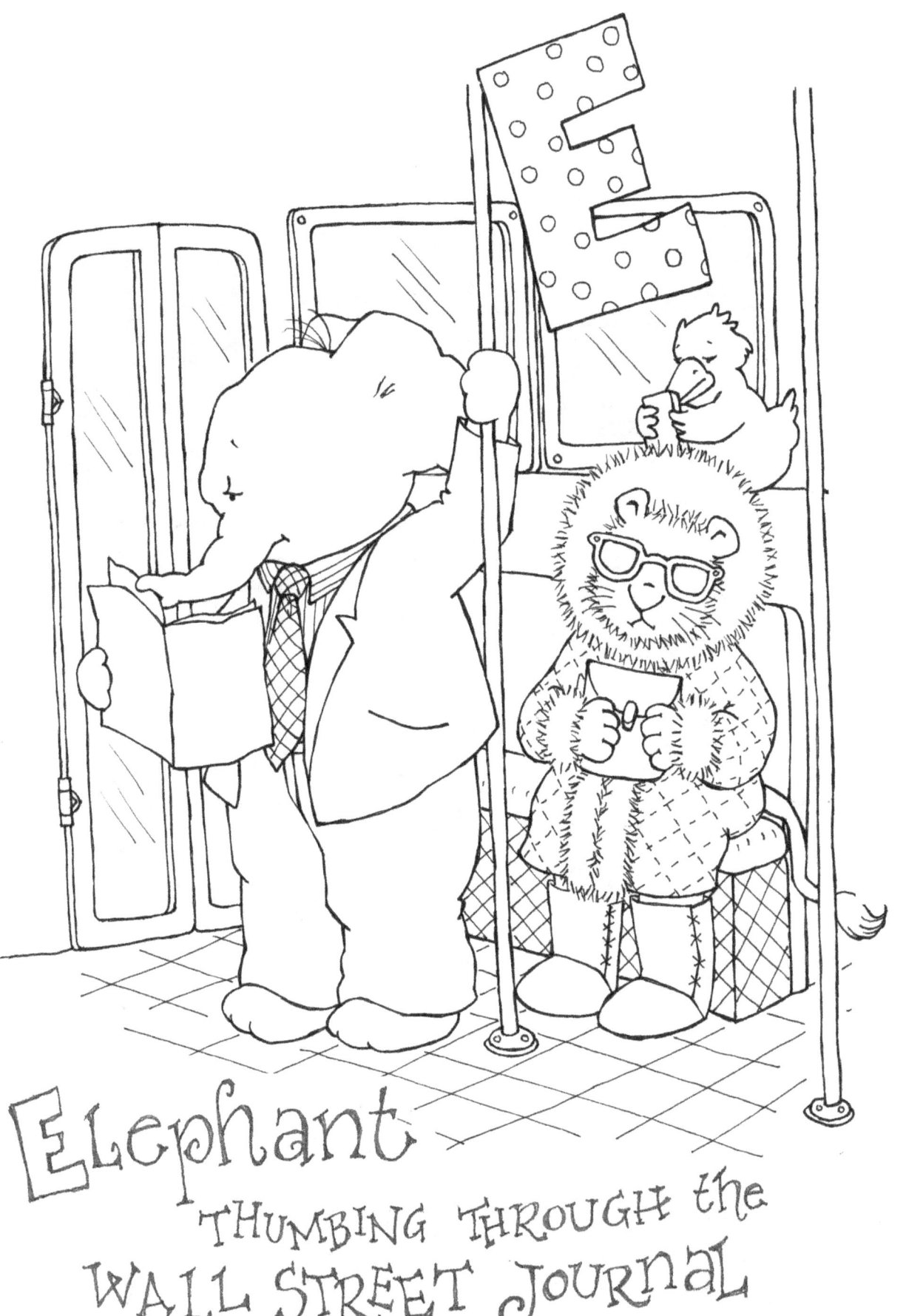

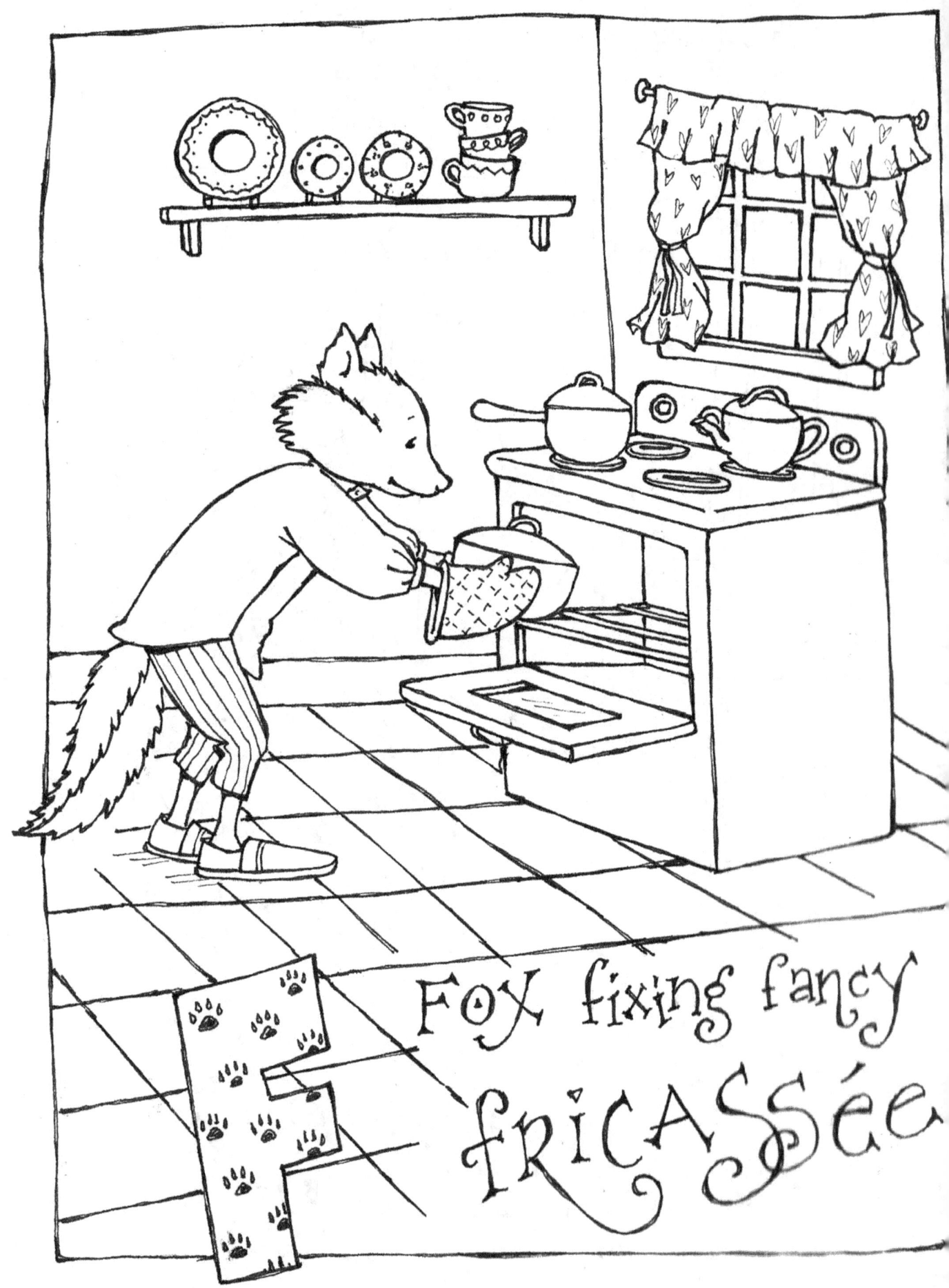

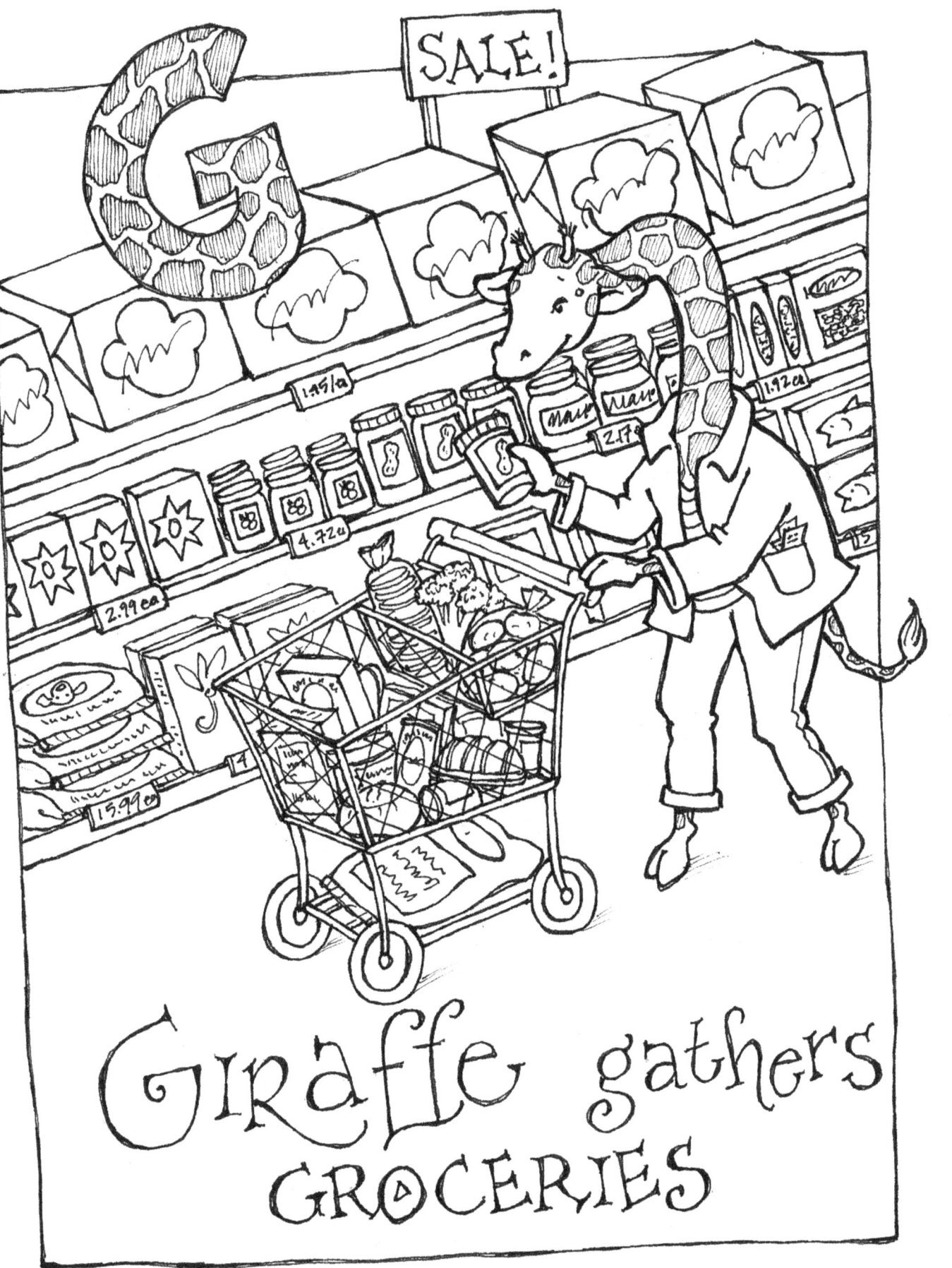

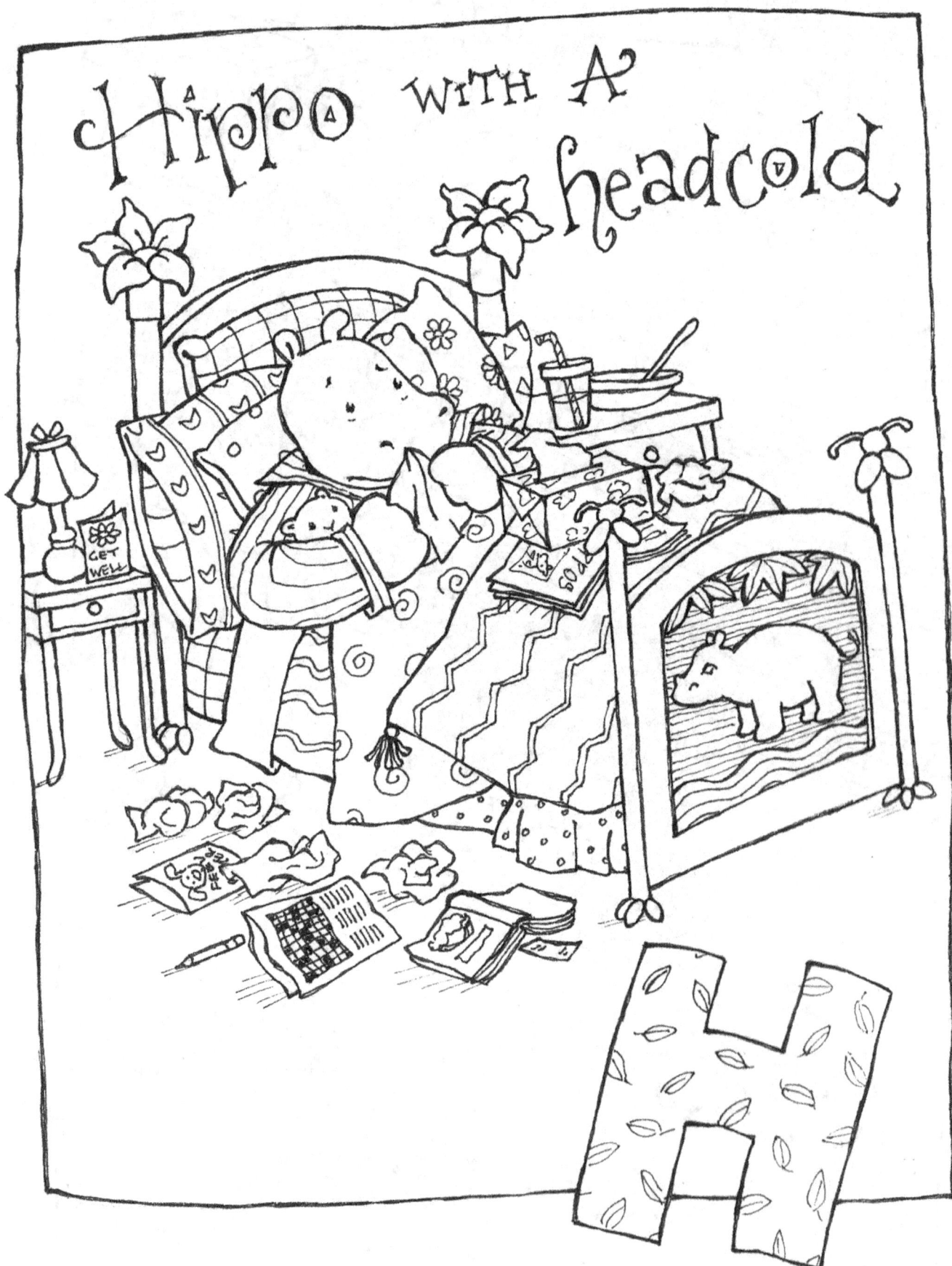

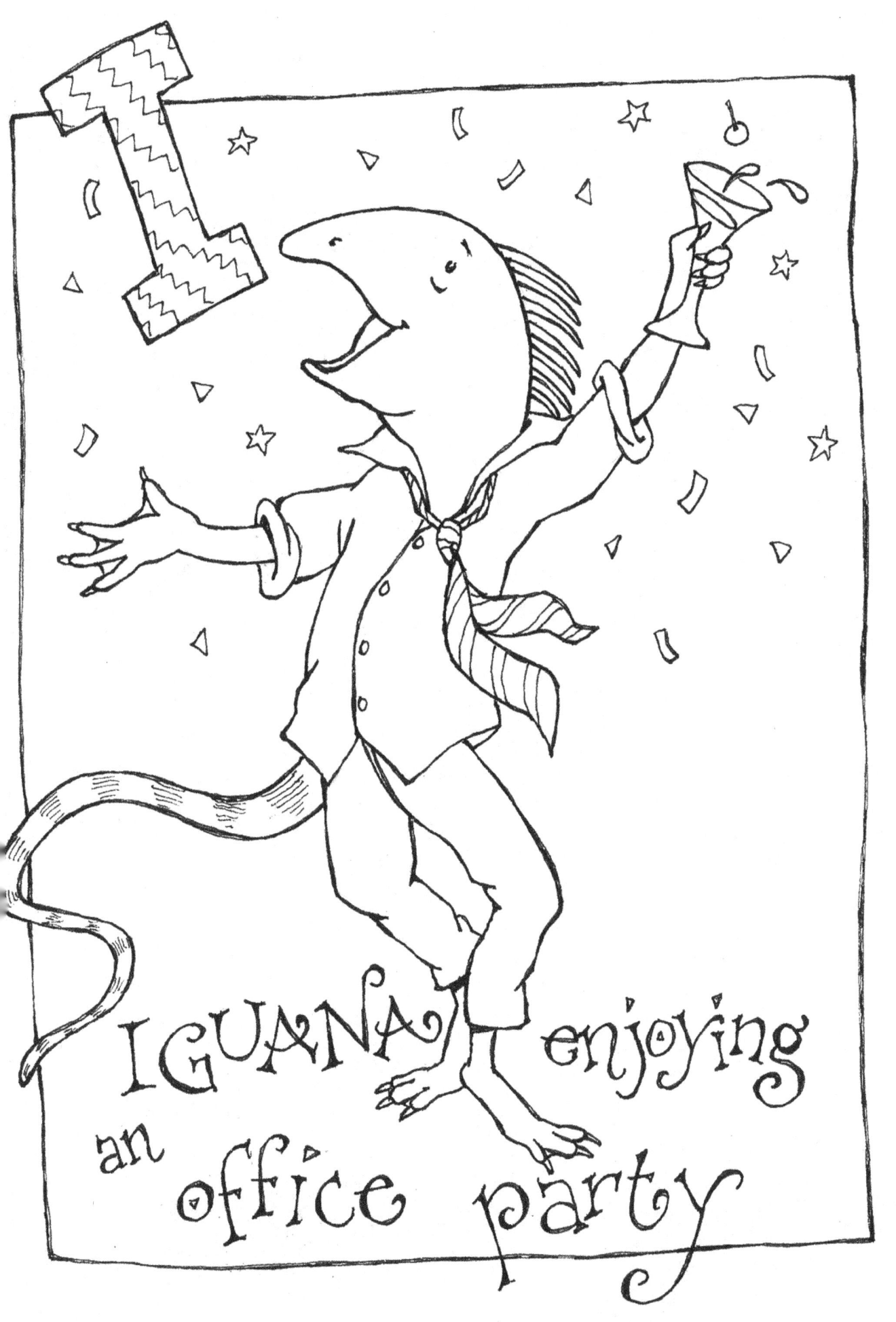

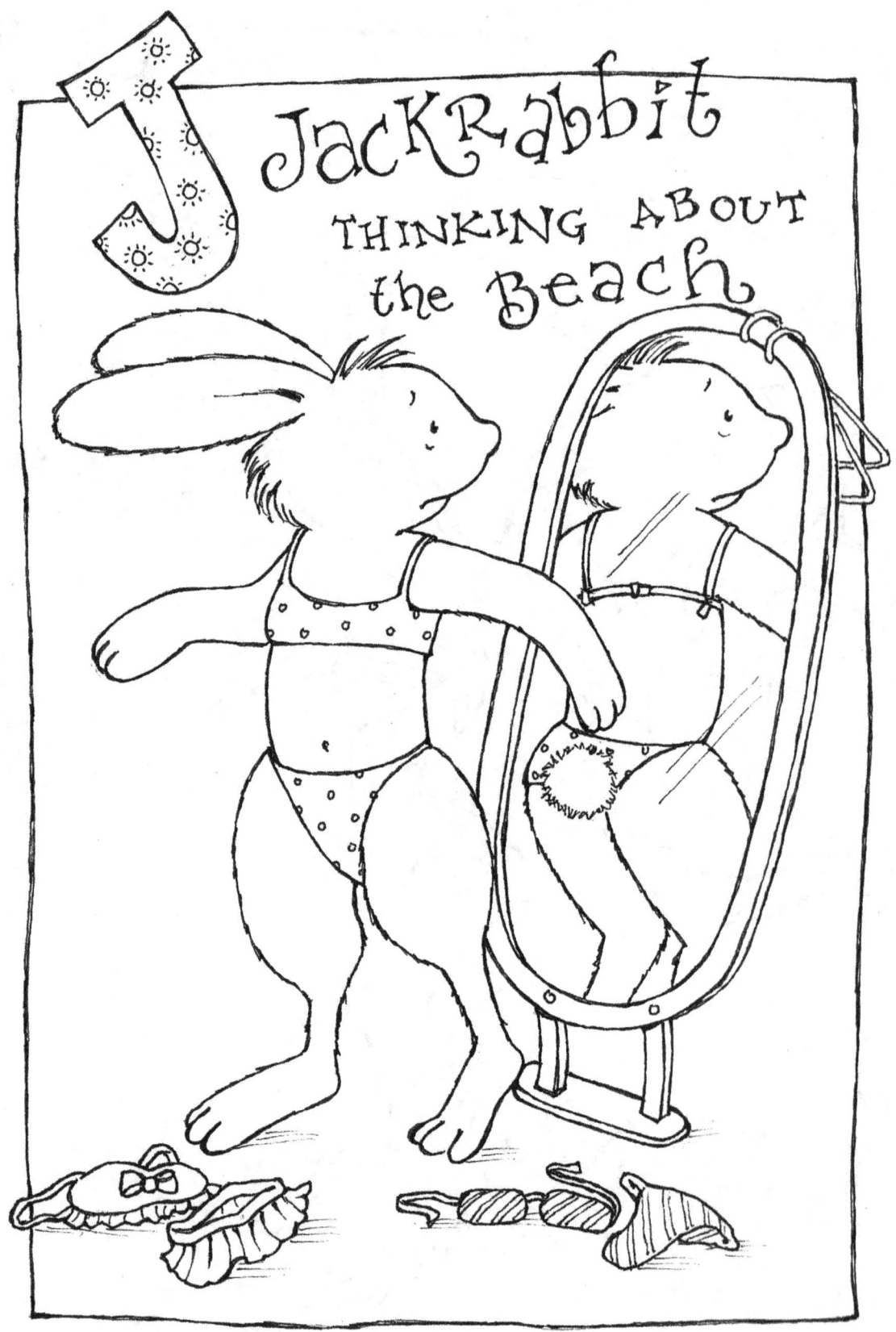

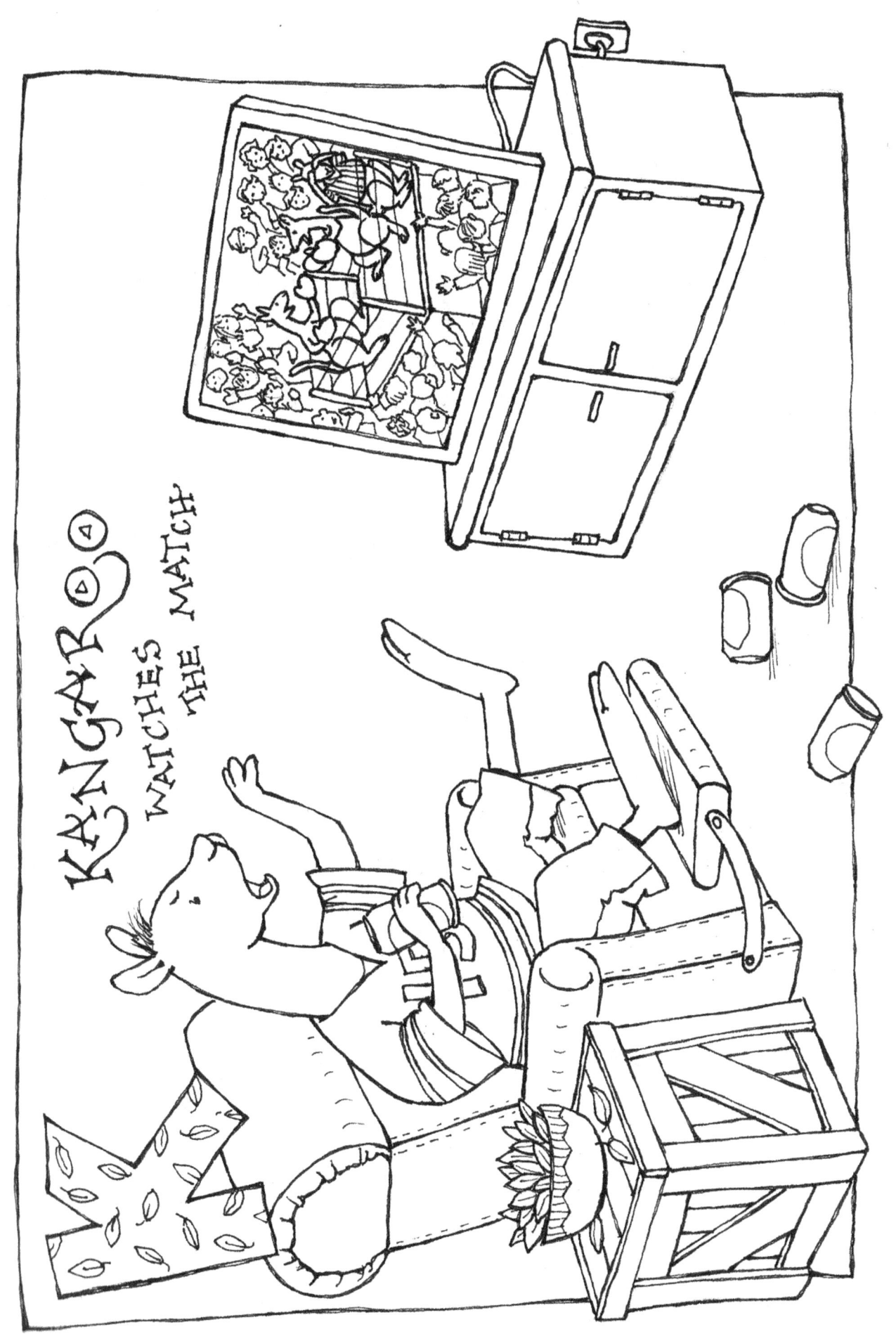

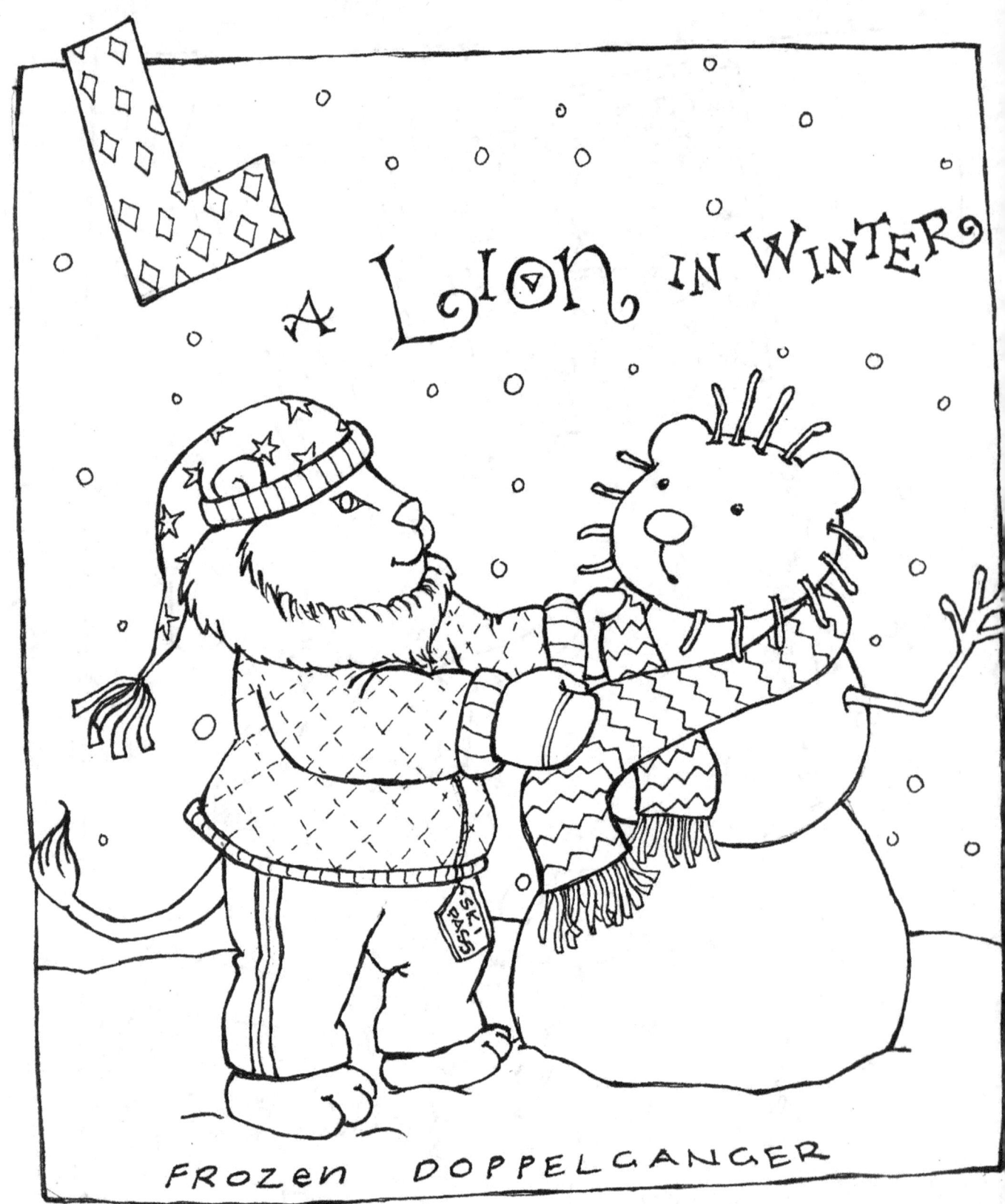

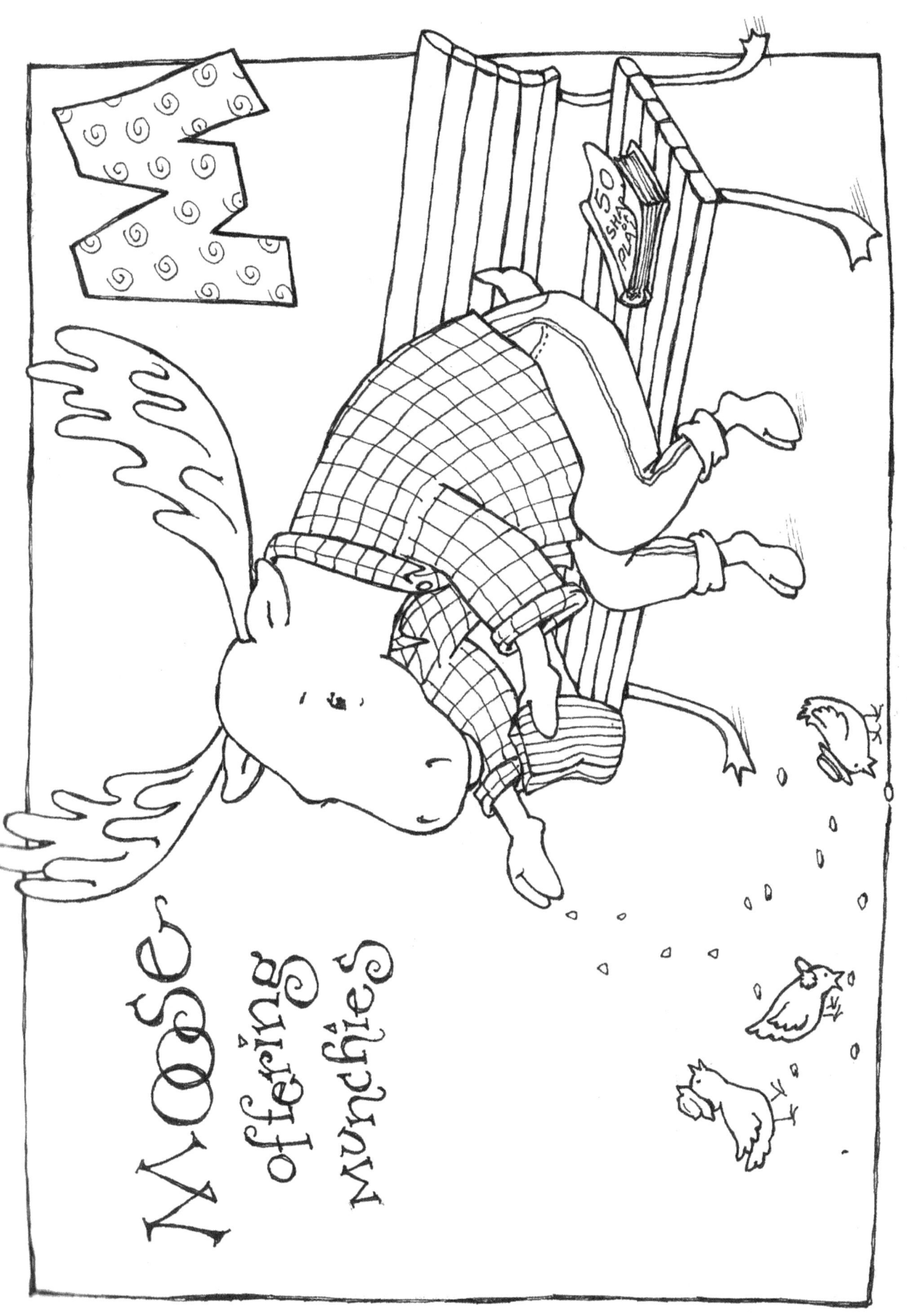

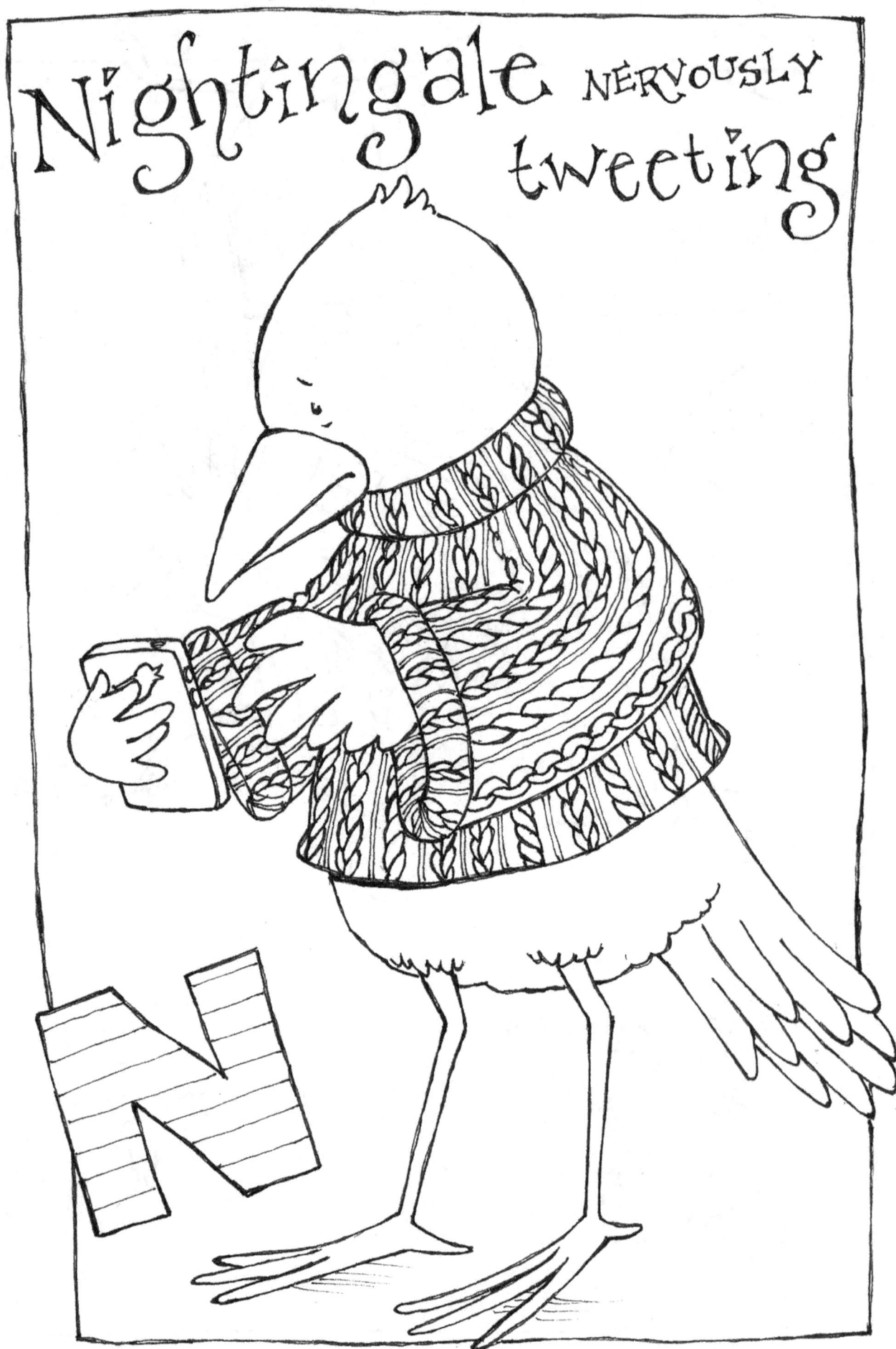

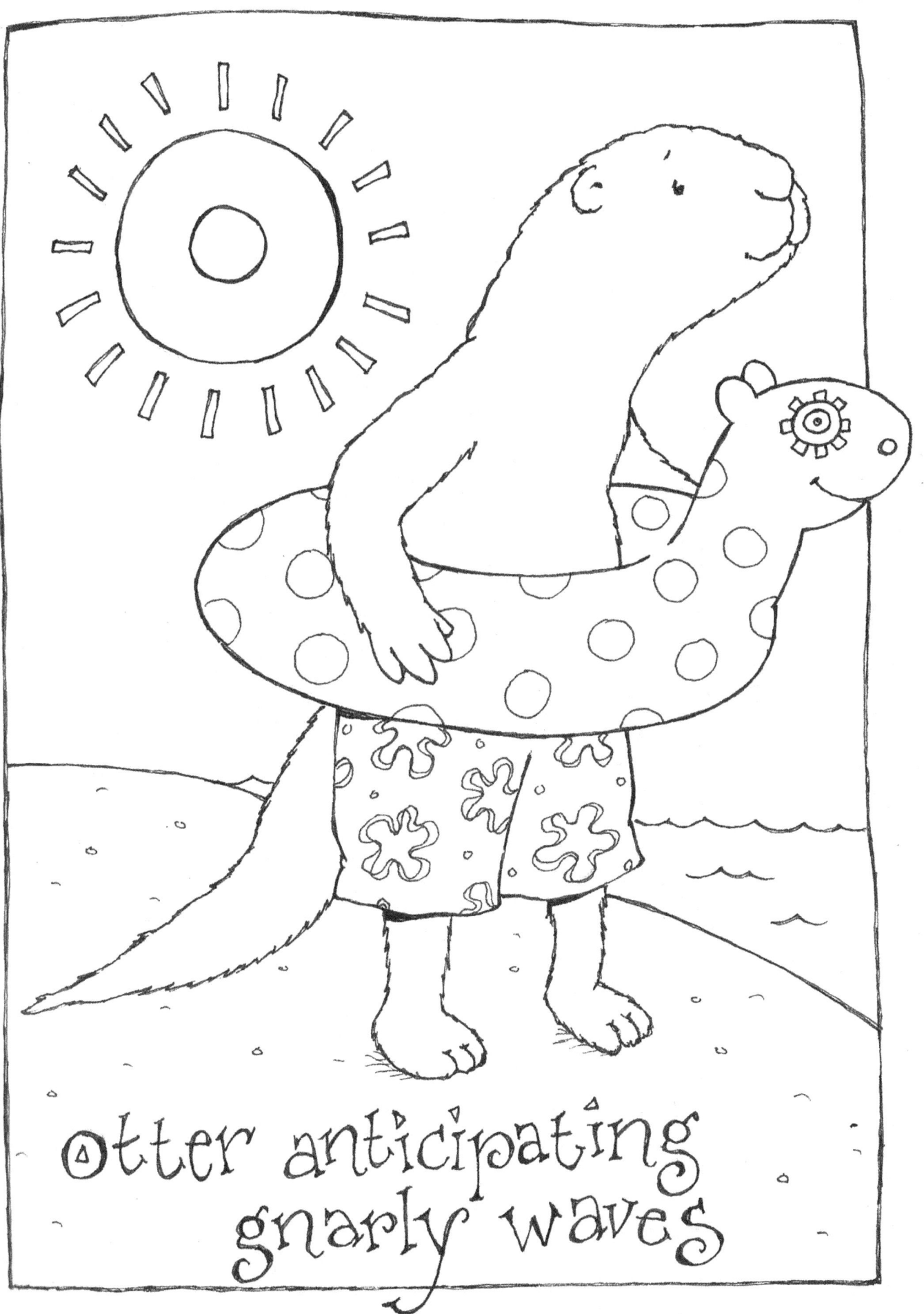

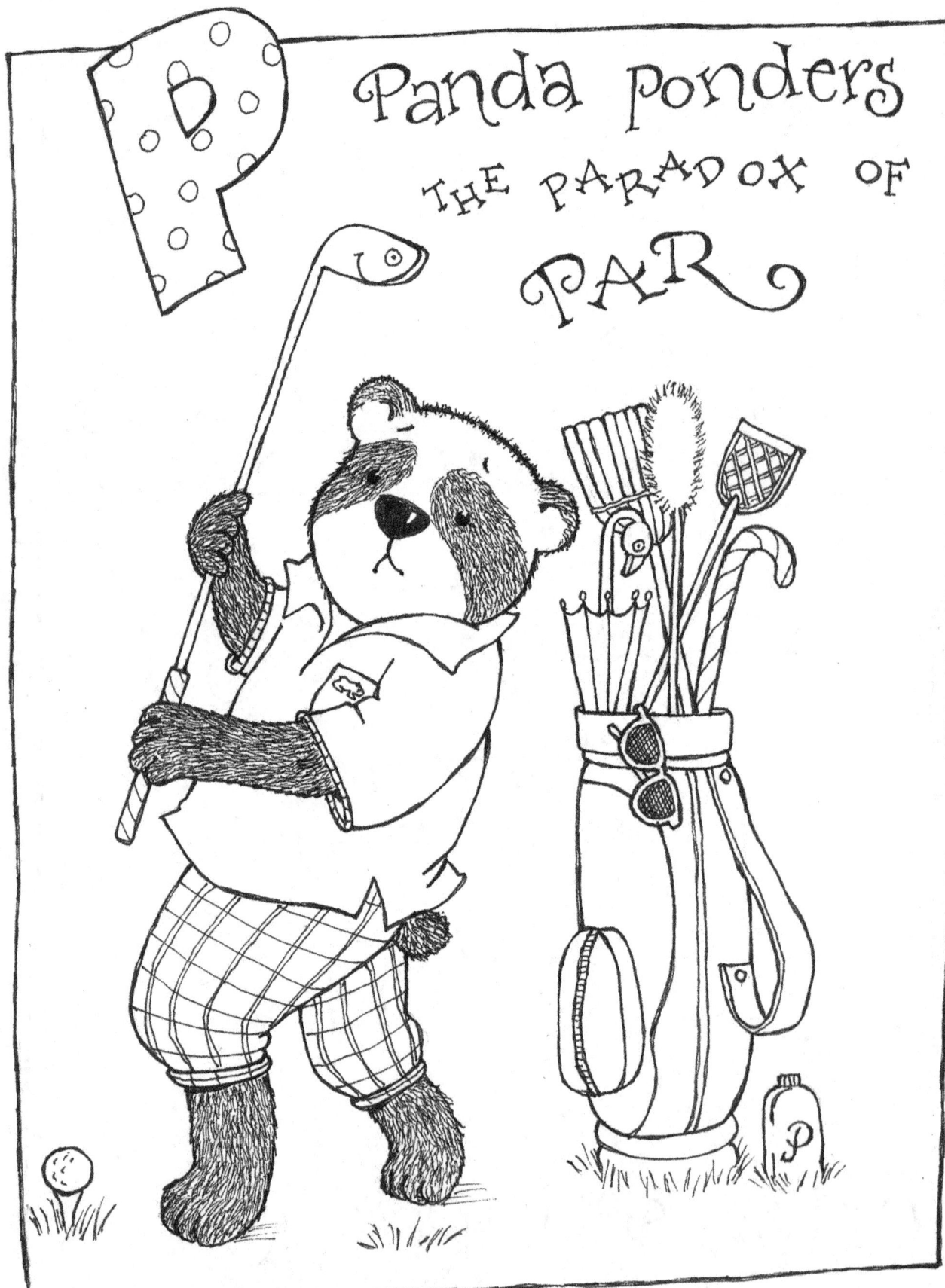

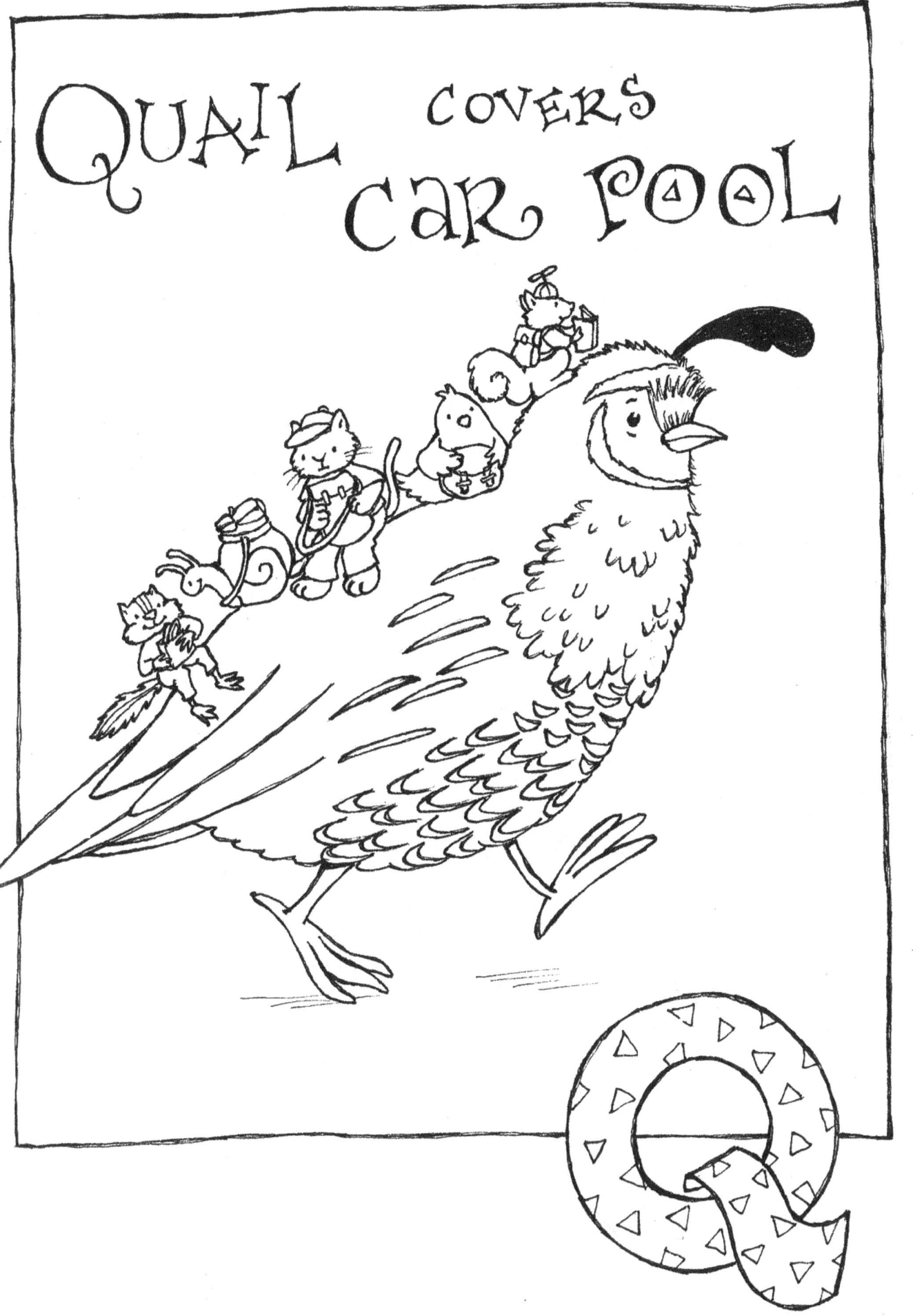

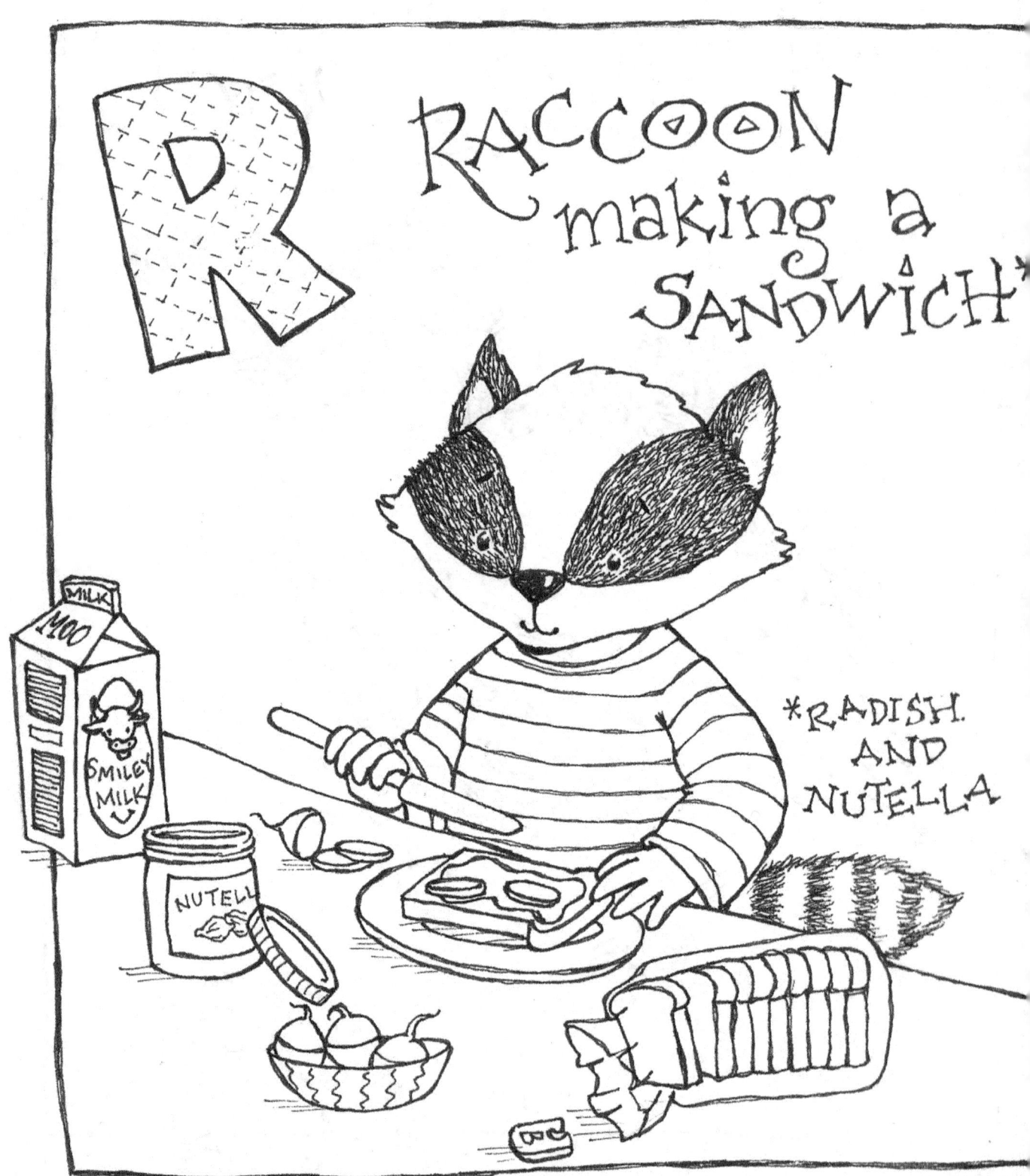

Spotted Snake in a Sweater Sipping Celery Soup

Useless Spoon

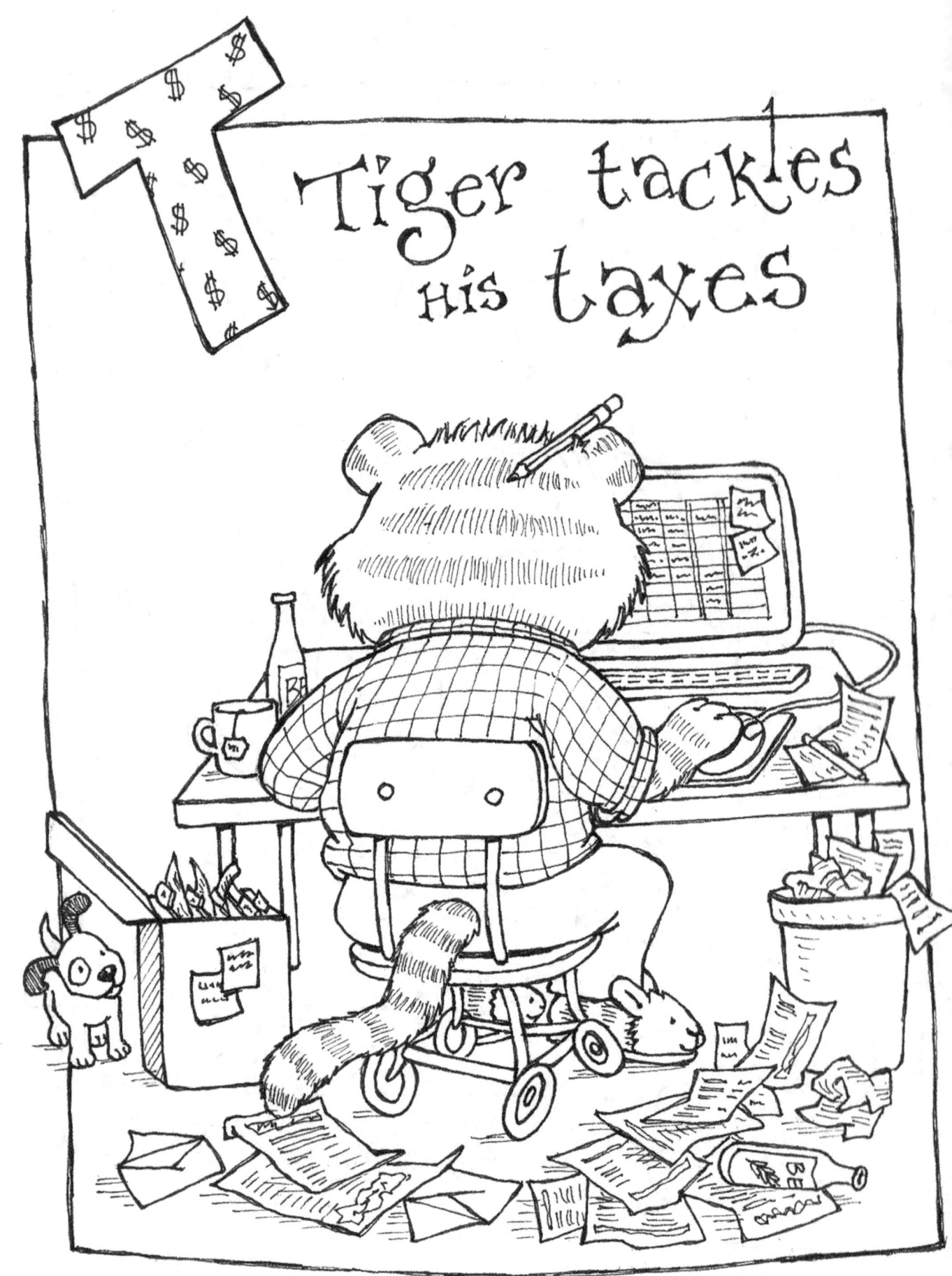

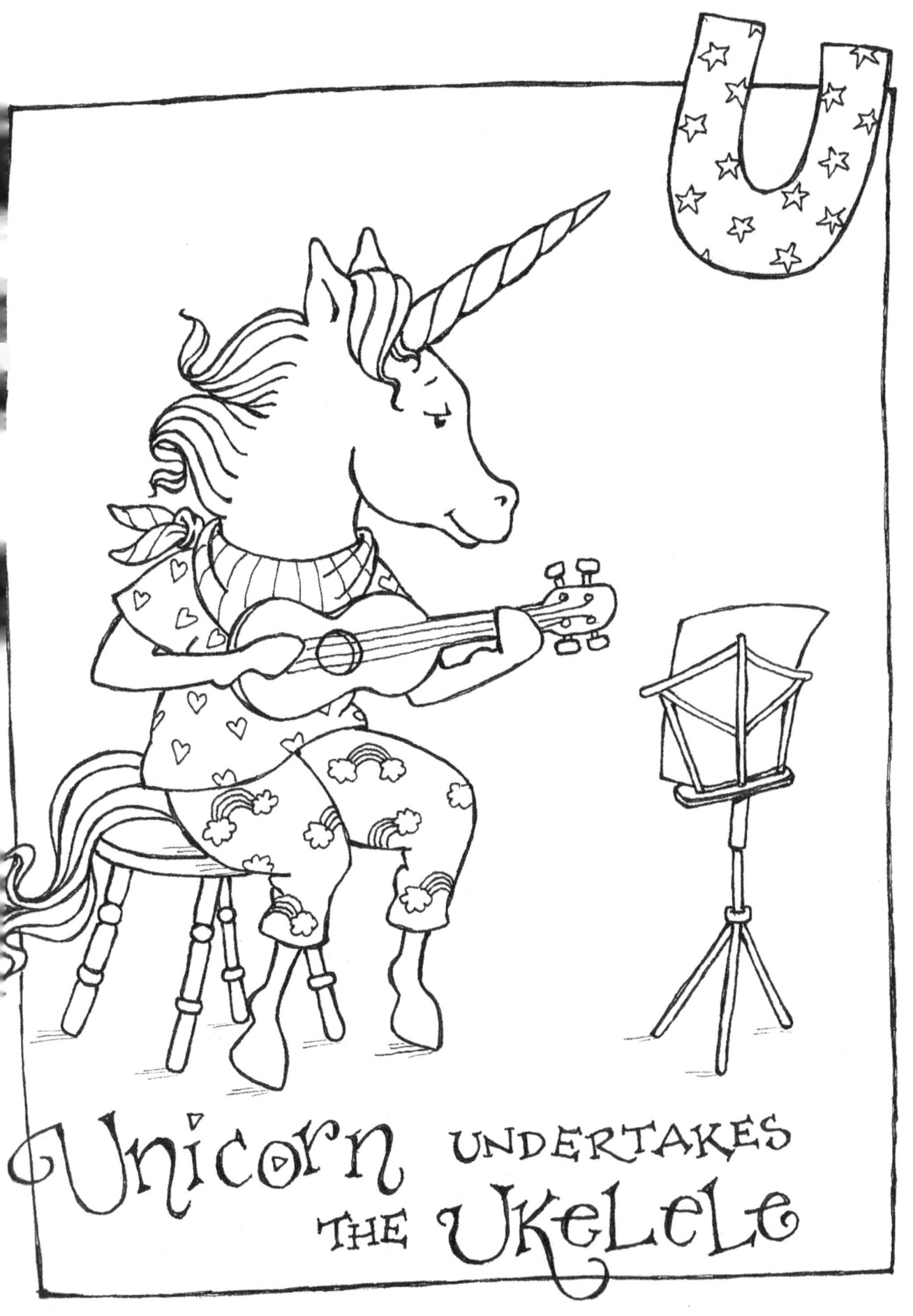

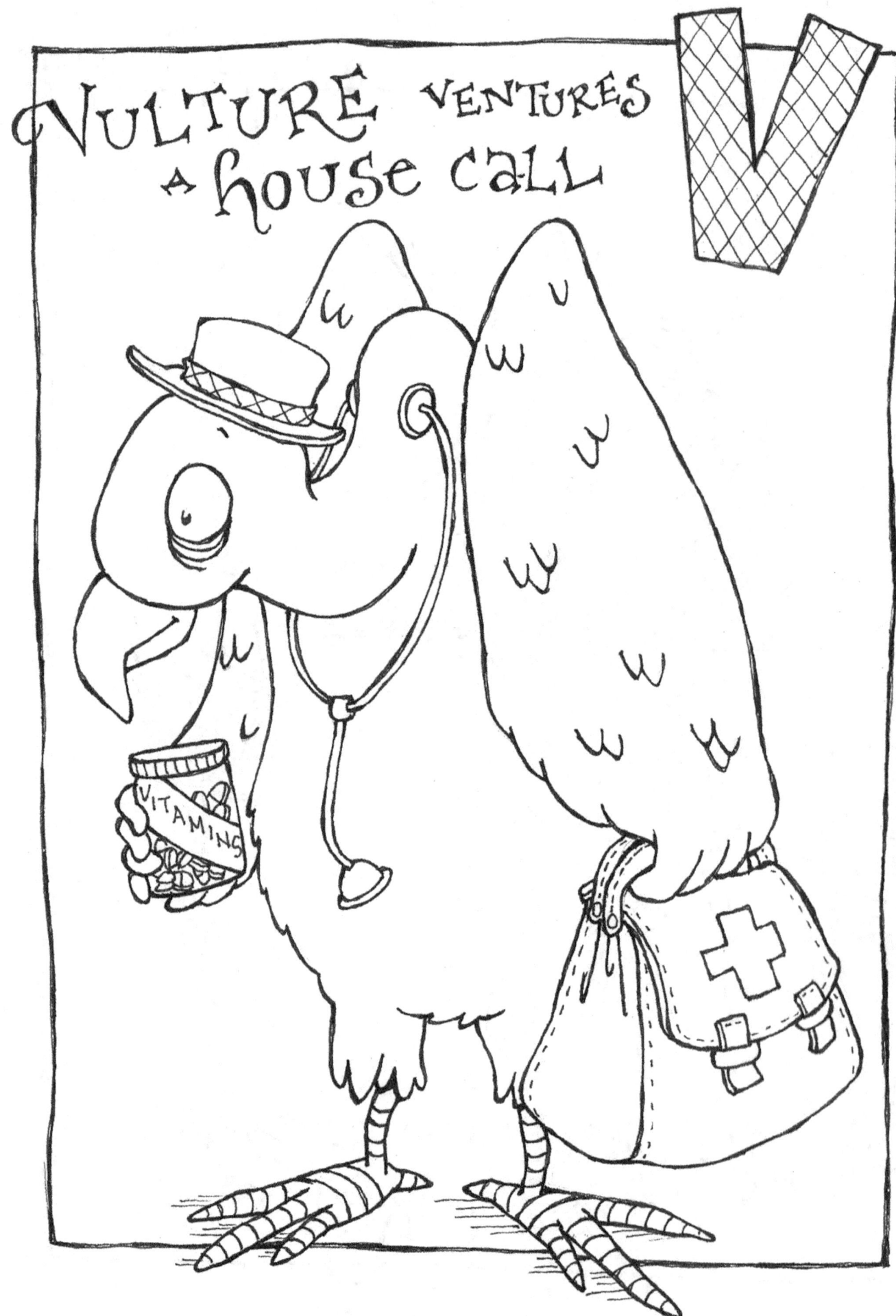

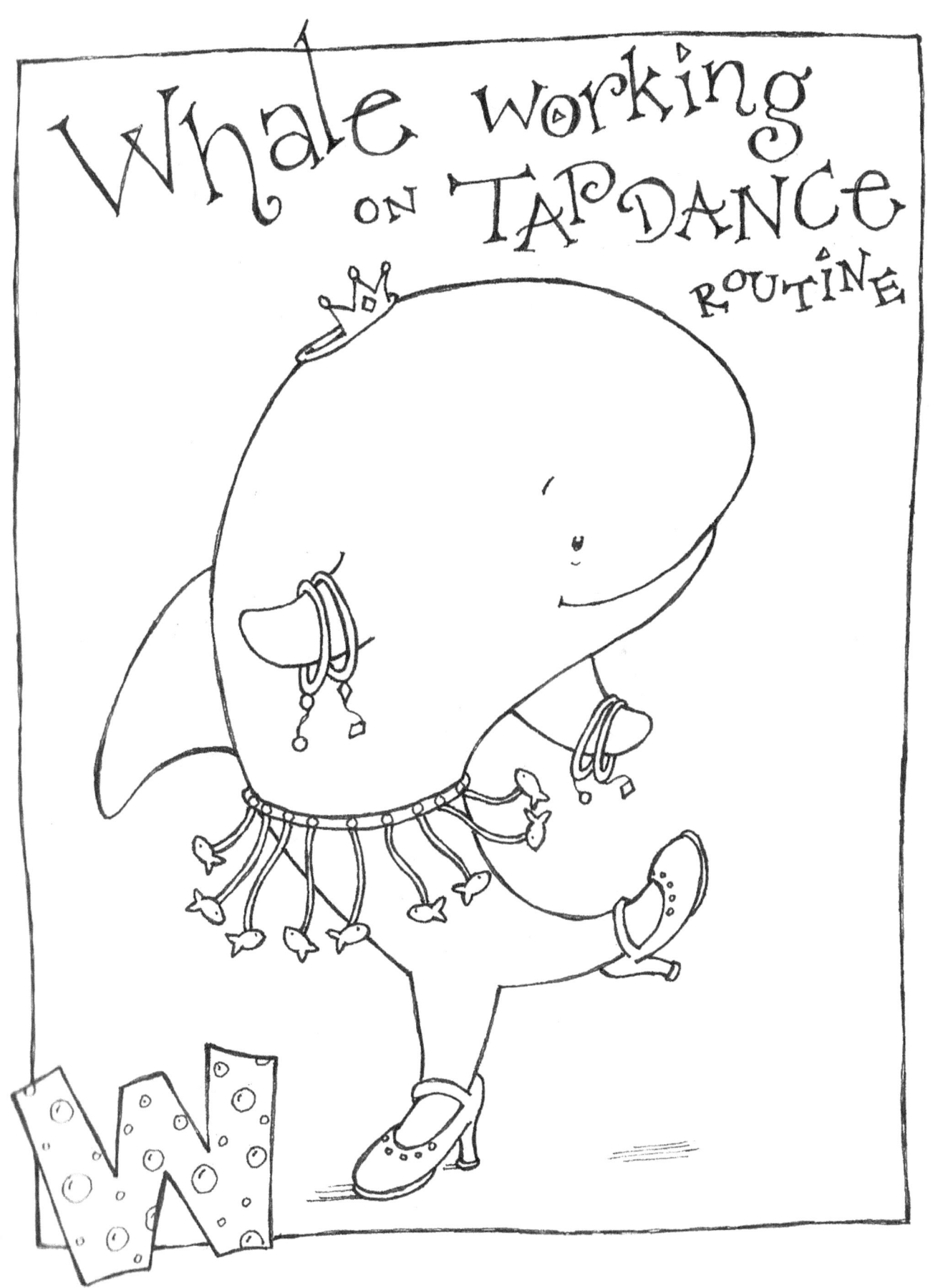

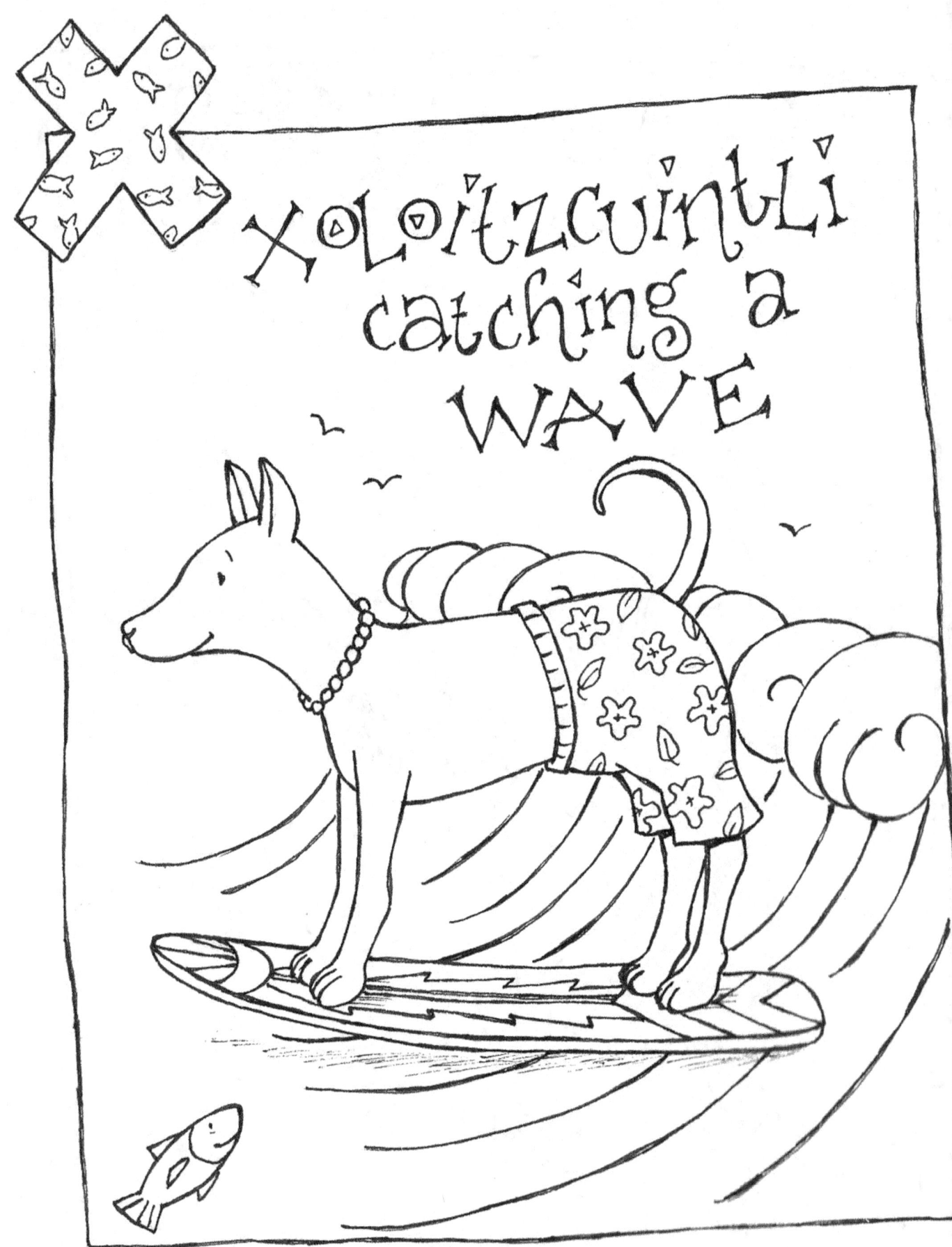

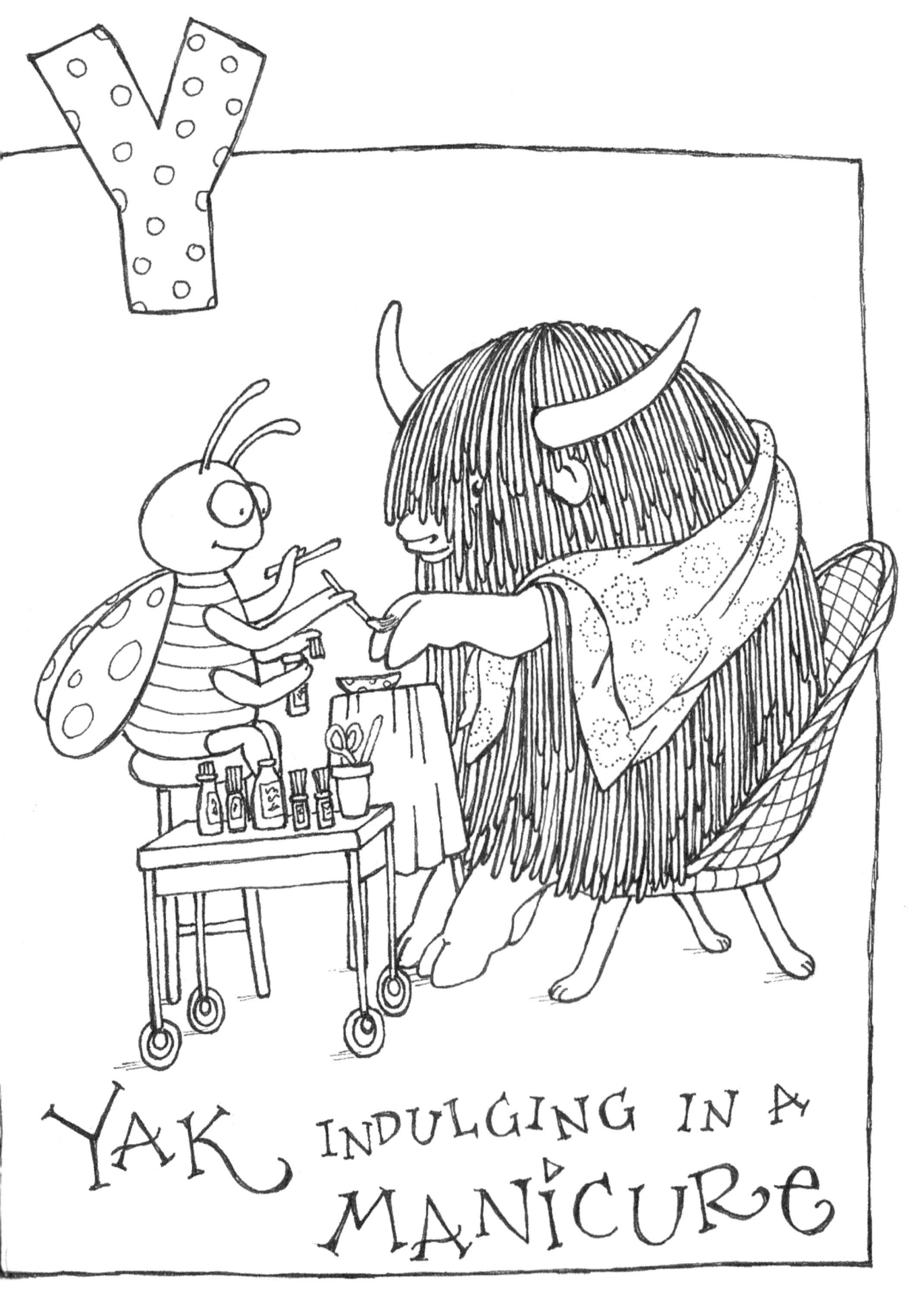

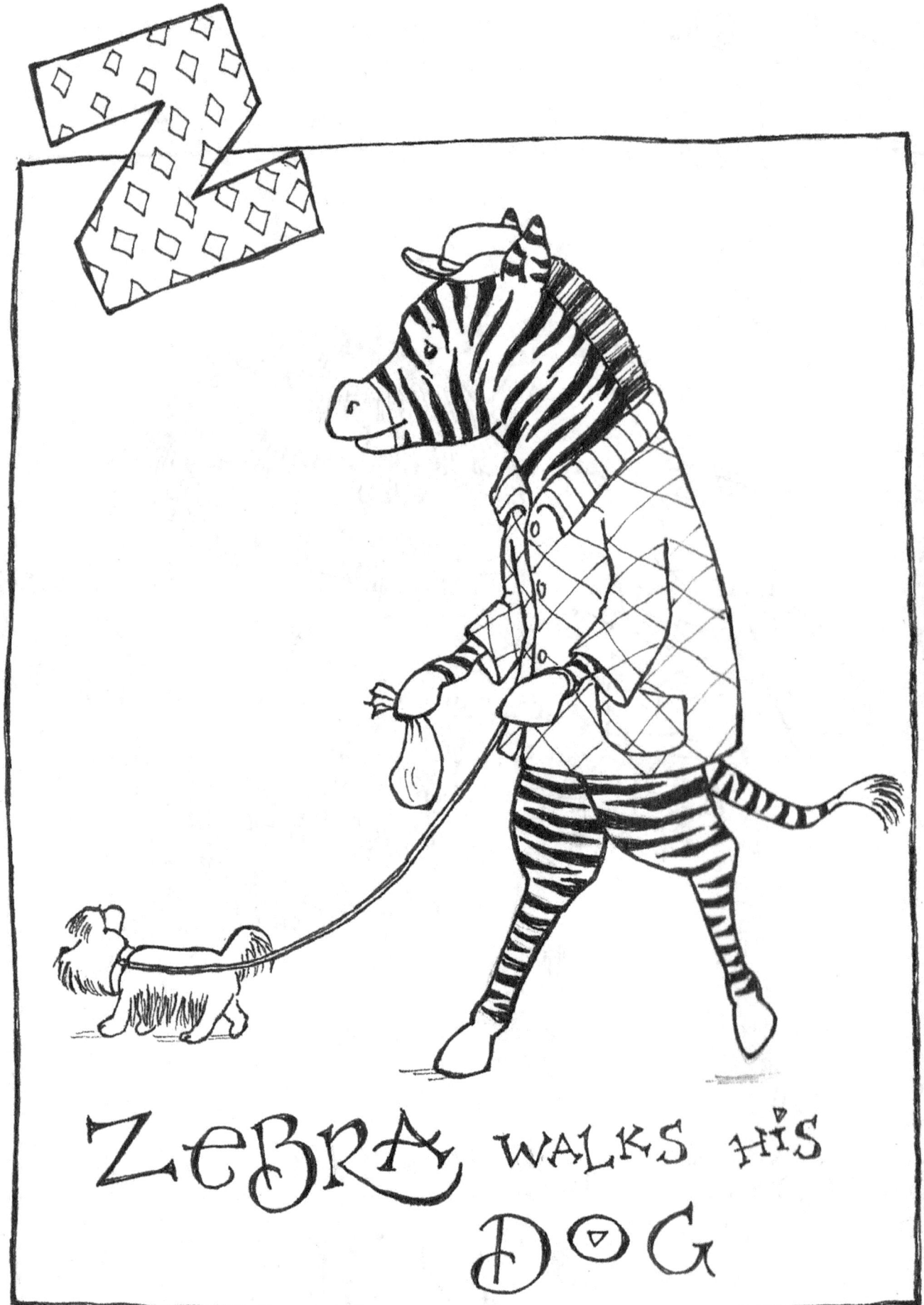

Draw & color your own picture here!

Make another picture here!

And another picture here!

www.ingramcontent.com/pod-product-compliance
Lightning Source LLC
Chambersburg PA
CBHW081148170526
45158CB00009BA/2771